ROGER HANGS OUT

HarperCollins*Publishers*

HarperCollins*Publishers*
77–85 Fulham Palace Road,
Hammersmith, London W6 8JB
www.harpercollins.co.uk

Published by HarperCollins*Publishers* 2007
1

www.rogertheweb.com

A catalogue record for this book
is available from the British Library

ISBN-13 978-0-00-723254-3
ISBN-10 0-00-723254-3

Printed and bound in Thailand by Imago

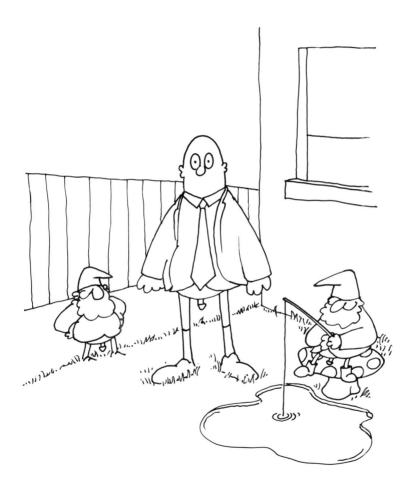

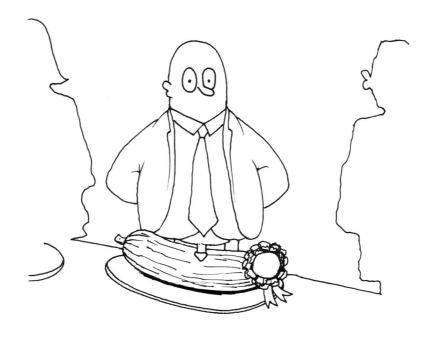

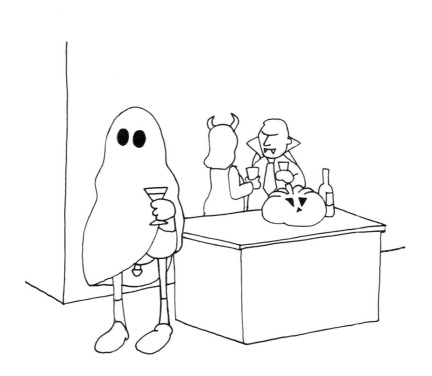

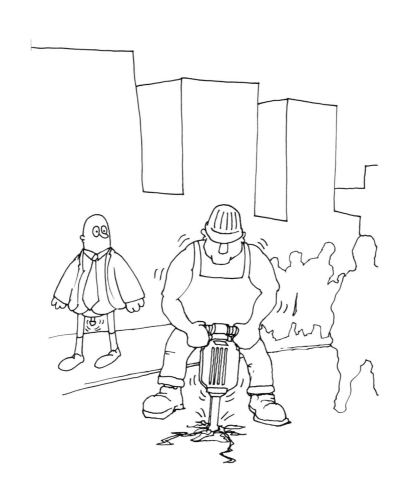